COSIMA VON BONIN
Character Appropriation

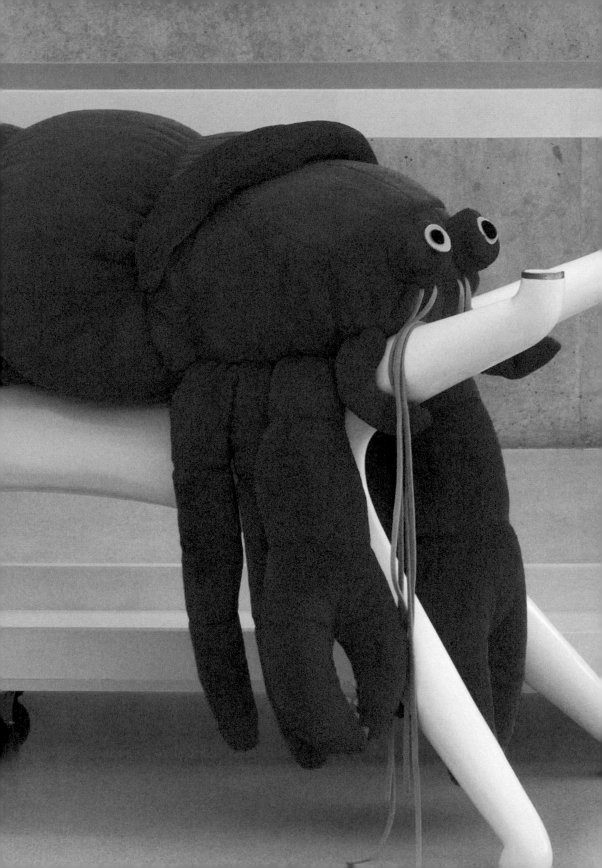

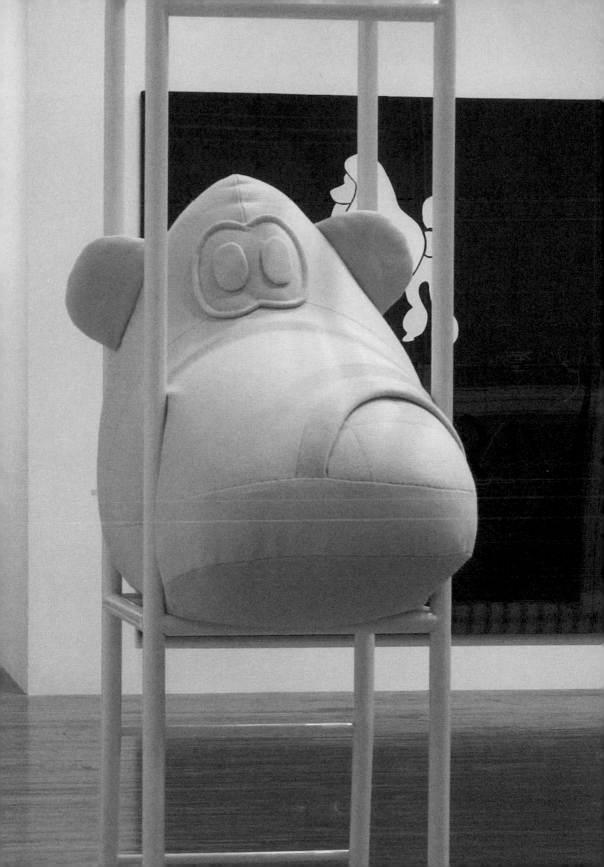

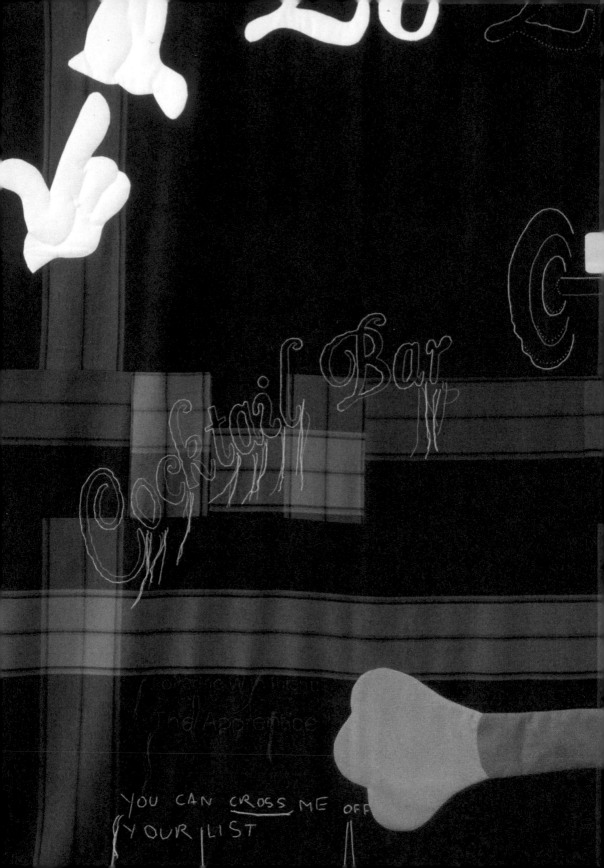

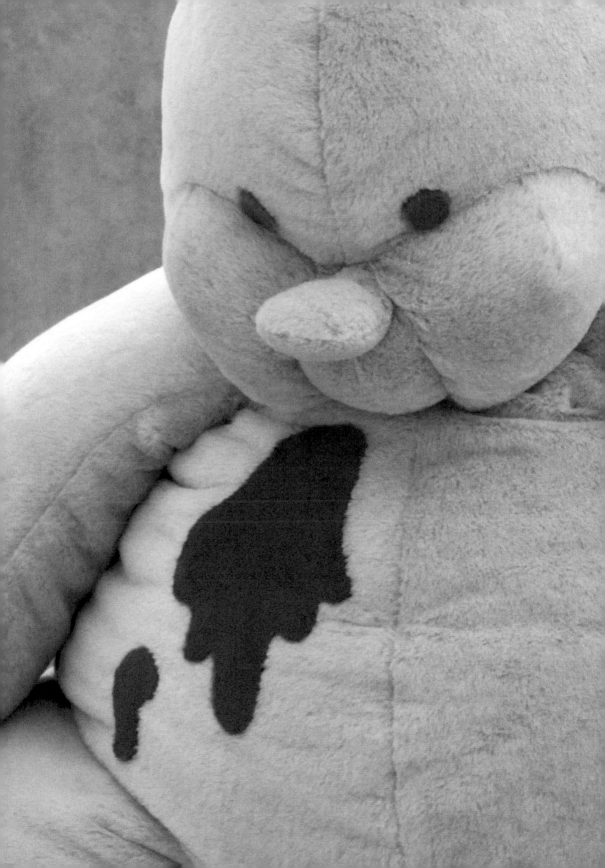

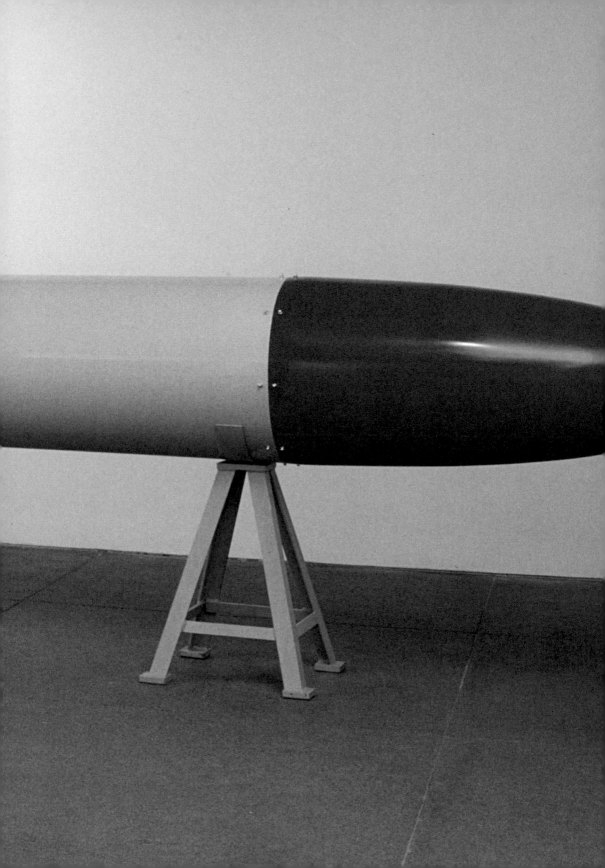

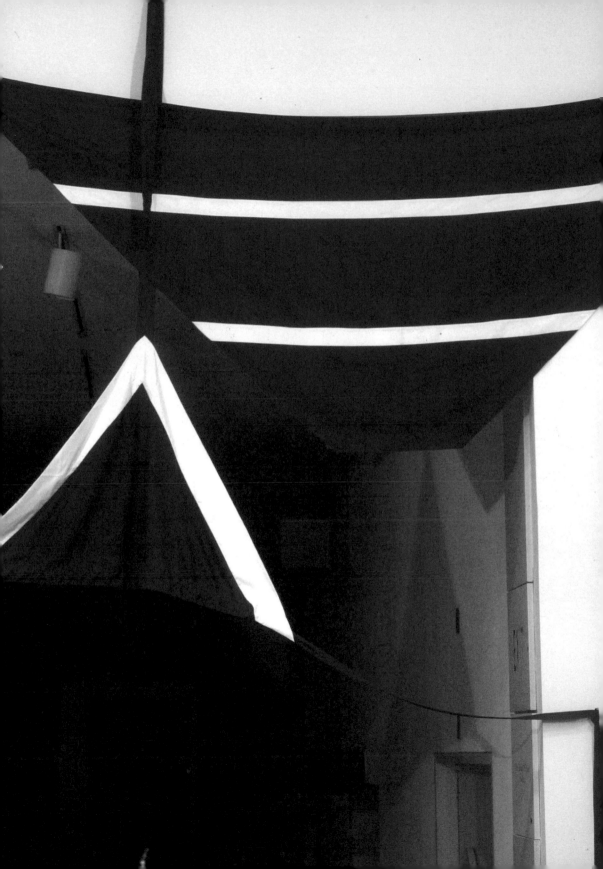

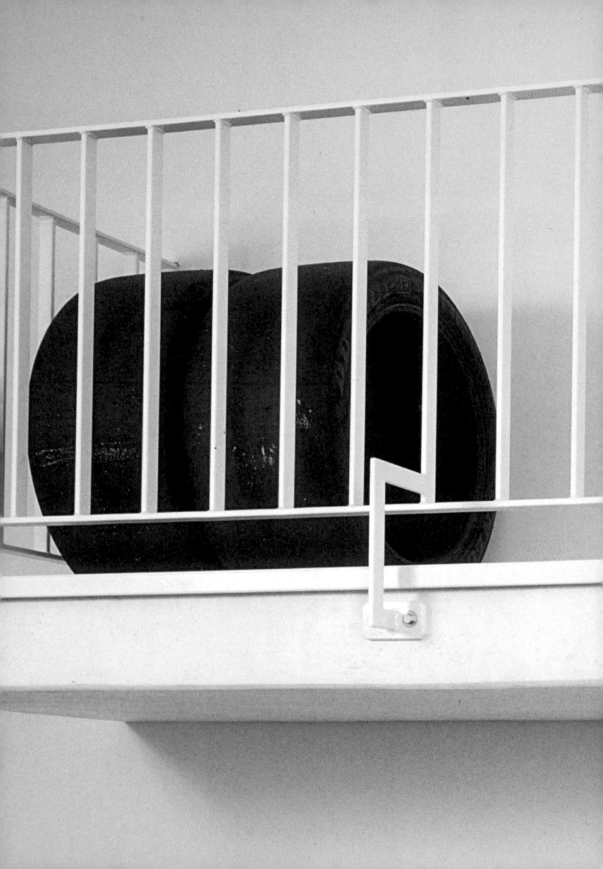

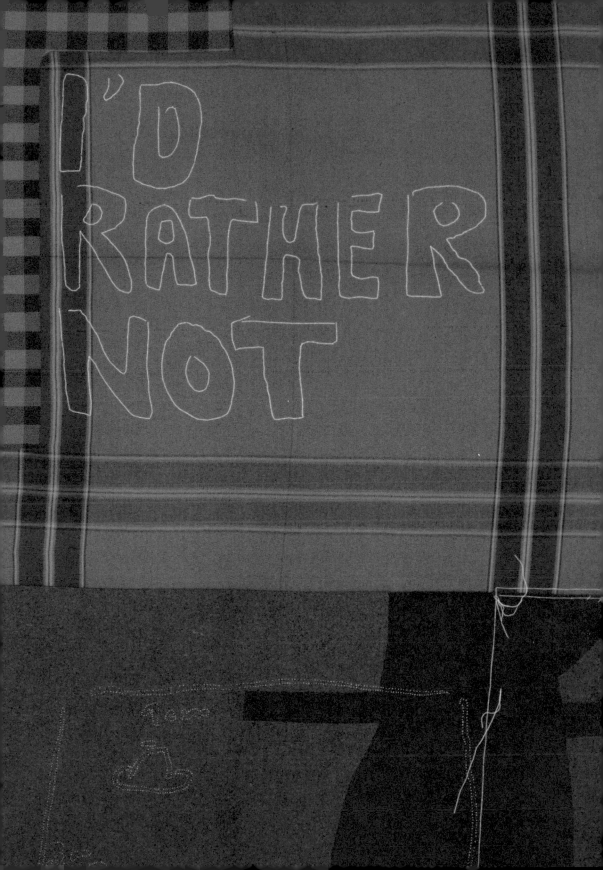

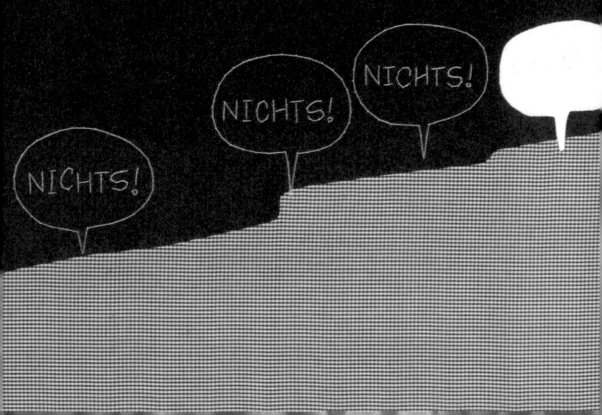

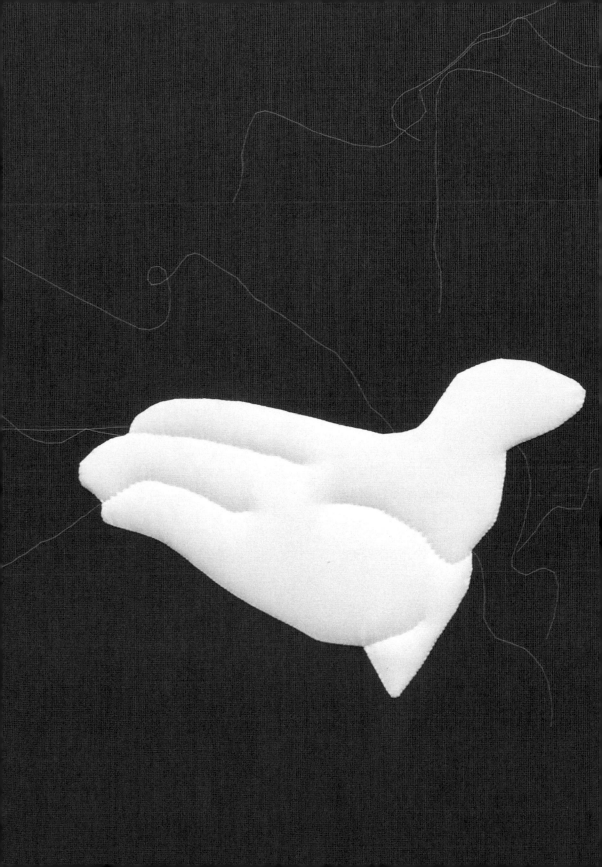

IT IS IMPOSSIBLE NOT TO BE ENTRANCED with Cosima von Bonin's seductive works. Her huge, floppy stuffed animals, outsized rockets, and large-scale textile "paintings" exude an alluring sweetness, and she brings to all of her art an irreverent sense of humor that asks us to laugh at as much as reflect upon the layered, often covert, references packed into her works. Employing an eclectic array of sources, including her own biography and the work of other artists, as well as popular culture, fashion, design, vernacular architecture, and music, von Bonin integrates different modes of cultural production and display in a cumulative practice that revels in their relationships and incongruities. The comic appeal of her work is countered by a creative deployment of binary relationships—hard and soft, masculine and feminine, engagement and estrangement—that introduces a more complex aspect to her practice, including an implicit commentary on more sobering subjects such as the ubiquity of consumerism, gender inequalities, and rising social apathy. In recent years, an increased use of anthropomorphized animals and repeated allusions to themes of mental and physical fatigue have come to dominate von Bonin's referential repertoire, suggesting both a reflection on a persistent feeling of exhaustion or malaise infiltrating today's global, networked society, and, on a more autobiographical level, a response to the unceasing demands placed on contemporary artists to produce, create, and exhibit.[1]

Von Bonin's work of the last decade revolves around three primary series—textile "paintings," oversized stuffed animals, and architectural sculptures—which the artist often combines in large-scale, materially affective installations. The question of meaning in her work is multilayered and mutable as she freely mixes older with newer elements from each series through a process of "looping"—a term taken from the

Cosima von Bonin: Character Appropriation

Meredith Malone

electronic music industry referring to a sampling technique in which a small section of sound is isolated and seamlessly repeated. By employing the loop as an aesthetic strategy, von Bonin eschews linear or fixed trajectories, creating instead multifarious collisions of possible meanings and motives.[2] While techniques of appropriation, citation, and pastiche are well-established tools within the modern art historical lexicon, the operative values underscoring her particular articulation of these modes is distinct.

Von Bonin's inventive practice of reorganizing and recycling, coupled with a strong proclivity toward collaboration, resonates with Nicolas Bourriaud's concept of "postproduction," a term coined to describe new types of appropriation in contemporary art that privilege mixing and editing of primary and secondary source materials in a manner akin to that of a contemporary DJ or programmer.[3] For Bourriaud, the DJ's sequencing and recombination of sounds and data flows reflect fundamentally changed notions of creation, authorship, and originality in a contemporary global culture driven by exchange and the rapid circulation of images and information. Similarly, in von Bonin's complex yet directly appealing installations, everything can be reconfigured and reshuffled in ever-changing arrangements. By continuously folding new works into her preexisting repertoire of motifs, forms, themes, and histories, the artist makes each installation a site of renewable production and meaning. But rather than merely embracing the generative possibilities offered by appropriation and sampling—acts so ubiquitous in contemporary art that they could be said to no longer signify anything in particular, devolving instead into empty forms of participation in which everyone can be both producer and consumer—von Bonin's creative mix of reference and installation as fundamental practices results

1 / In 2010, von Bonin presented a major exhibition of new works at Kunsthaus Bregenz titled The Fatigue Empire accompanied by the catalog Cosima von Bonin: The Fatigue Empire, ed. Yilmaz Dziewior (Bregenz: Kunsthaus Bregenz, 2010). 2 / Von Bonin has recently embarked on a series of looping exhibitions. The Lazy Susan series began in October 2010 at the Witte de With with the exhibition Cosima von Bonin's Far Niente for Witte de With's Sloth Section, Loop #01 of the Lazy Susan Series, A Rotating Exhibition 2010–2011. The exhibition was accompanied by a catalog, Cosima von Bonin, Source Book 9 (Rotterdam: Witte de With, 2011). The loops continue with venues in Bristol, Geneva, and Cologne. 3 / See Nicolas Bourriaud, Postproduction: Culture as Screenplay: How Art Reprograms the World, trans. Jeanine Herman (New York: Lukas & Sternberg, 2002).

in powerful disjunctions that work to dramatize forms of cultural valuation and domination present in both art and society.

•••

The configurations von Bonin orchestrates in her installations often resemble stage sets, with her large stuffed animals cast as protagonists and multiple pieces of architectural sculpture alternately positioned as partitions or obstacles to be navigated by the visitor. For instance, when placed within the confines of a museum or gallery the imposing form of MISS RILEY (LOOP #02) (2006), a thirty-six-foot-long horizontal rocket with a red steel tip, forces viewers to actively position themselves in relation to it. A nod to the phenomenological play of Minimalism is implicit here, while the form of the rocket itself reads variously as a weapon of mass destruction, a phallic surrogate, and a glorified stage prop.[4] The rocket conjures images of military might, and yet its generic character, overt artificiality, and diminutive title render it impotent—a comic mockery of stereotypical notions of both masculinity and the often macho basis of much avant-garde rhetoric. Von Bonin's most recent adaptation of this work involves the addition of a gigantic stuffed chick complete with riding saddle mounted atop the missile's head. With this modification, she introduces a new "loop" that provokes further emotive triggers and a multitude of associations depending on the viewer's inclinations. The chick's cheeky moniker, MISSY MISDEMEANOUR (a crime less serious than a felony), invokes the image of a juvenile delinquent, drunk and joyriding around town in a stolen vehicle, while also drawing an associative link to contemporary American female rap artist Missy "Misdemeanor" Elliott. The provocative juxtaposition of a saddled rider straddling a rocket calls to mind numerous pop cultural icons, such as Major T. J. "King" Kong and his outlandish ride on the atom bomb at

4 / MISS RILEY is the second in a series of loops, the first being RILEY (2002). Von Bonin has produced five loops of this rocket to date. In the fifth loop, the artist altered the color combinations. Instead of a grey body and a red tip, the rocket is green with a suggestive pink tip.

the end of Stanley Kubrick's iconic film *Dr. Strangelove*—a political satire released in 1964 lampooning the nuclear scare and associated Cold War rhetoric—or the Looney Tunes character Wile E. Coyote and his misguided, always disastrous implementation of ACME brand products, including rockets, to catch his nemesis, the Road Runner.[5] But unlike Wile E. Coyote, who miraculously bounces back unscathed from every calamity, this chick is clearly overtaxed, slumped over and covered in its own vomit while being lulled into a stupor by hypnotic club music. The source of this poor creature's weariness is left unclear, open to myriad projections. One might proffer an interpretation of the piece as a satirical commentary on contemporary society's desensitized relationship to violence and weapons. Or, pushing it a step further, we might see this comic juxtaposition of rocket and chick as a sly reflection on a pervasive feeling of social apathy and melancholy in which social commentary itself is presented as increasingly fatiguing and fatigued, the energy of protest exhausted and dispersed. Faced with an inability to imagine any alternatives to today's global system of consumer capitalism, a system which itself has no social goals, the individual is left estranged and depleted.[6]

Admittedly, this may be placing too much weight on one chick's shoulders. Nevertheless, von Bonin's proliferating production of sluggish animals, including oversized rabbits with the word *sloth* embroidered into their paws, lazy hermit crabs, and cartoon dogs, begs the question, what does it mean for an artist to take up the theme of inactivity? Is the choice of subject really an expression of a strong desire to be idle, to dismount and break free from incessant cycles of production, consumption, and fatigue? The addition of torpid club tracks composed by electronic music producer Moritz von Oswald as immersive soundscapes for von Bonin's

5 / Looney Tunes and Disney characters appear in many of von Bonin's works, including MARATHON #01 (2007), which is comprised of numerous commercially produced stuffed versions of cartoon characters animals, including Wile E. Coyote (atop a rocket), Goofy, and Mickey Mouse, all hanging from a series of clotheslines.

6 / Fredric Jameson's writings on globalization connect well to this interpretation. See especially his essay, "Globalization and Political Strategy," *New Left Review* 4 (July/August 2000): 49–68.

overstuffed animals offers a further emotional stimulus to the artist's already compelling installations.[7] Unlike pop music's characteristic lyric-driven melodies and predictable trajectories of verse and chorus, the cool tempos and seeming lack of organization in these rhythmic soundtracks distract as much as seduce with their mesmerizing beats, leaving the viewer in a state of irresolution.

The productive tensions and suggestive ambiguities arising from von Bonin's implementation of juxtaposition and reference are compounded in her textile "paintings" (or "rags," as she calls them). These large-scale works are made from a variety of industrially produced fabrics (wool, felt, cotton, loden) stitched with appropriated imagery, appliquéd shapes, and short phrases of resistance, discontent, or ennui written in a variety of languages—"harmonie ist eine strategie," "I'd rather not," "more the memory of a shrimp"—that recur in multiple works. Striking for their large scale, tactile appeal, and rich visual density, von Bonin's textile paintings enact a series of productive slippages between art and architecture, drawing and stitching, painting and sewing, fine art and popular culture, masculine and feminine. Stretched like a canvas, the works often look and act like paintings, but their identity is never fixed. They remain remarkably adaptable, serving both aesthetic and utilitarian purposes. Textile paintings can be hung on the wall, but they may also be displayed as three-dimensional objects suspended from the ceiling or mounted on low pedestals on the floor, functioning simultaneously as paintings, sculptures, screens, signs, or walls that require both physical and conceptual negotiation.

Each composition represents a mash-up of heterogeneous aesthetic universes: cartoon imagery, American popular culture, designer fashions, myriad personal references, queer

7 / Since the early days of her practice, von Bonin's approach to art-making has been defined by a creative citation of and collaboration with other artists. Breaking with facile notions of appropriation as a one-sided form of taking, she enters into reciprocal collaborations as her projects dictate. Von Bonin first met von Oswald in 2009 and began collaborating with him soon after—a collaboration that not only informs her art, but also his: she has contributed the cover art for several of his albums, including the Moritz von Oswald Trio's 2009 album *Vertical Ascent*, which features an image of von Bonin's rocket MISS RILEY; the 2010 album *Live in New York*, which displays an image of the artist's rainbow-colored rolling pin COLOUR WHEEL; and the 2011 album *Horizontal Structures*, which features the work BONE & DUBPLATE.

culture, and modern and conceptual art. The cultivation of such links and networks has been a key facet of von Bonin's artistic production since the 1990s, with critics and art historians often tempted to tease out the range of loaded art-historical connections and influences that underscore this series. For instance, von Bonin's use of stretched fabrics formally recalls Blinky Palermo's sewn monochrome canvases that challenged the conventions and inflated rhetoric of abstract painting in the late 1960s and 1970s; her embedded satirical references to consumer society share an affinity with Sigmar Polke's ironic pieces made using tacky readymade fabrics to parody the claims of high modernist art; and her choice of textiles and their feminist subtext suggest a link to Rosemarie Trockel's work. Yet these oft-made connections are but one aspect of the artist's complex of contingent associations.

In a work such as ROCKSTARS (CHARACTER APPROPRIATION) (2003), pointed statements and arbitrary citations collide, layering into the work's art-historical references a range of additional signifiers that create countless links to other media and cultural contexts. The square composition is dominated by a large circle sewn together using sections of loden, a material that looks like felt, and a blue-black plaid wool whose bold, gridded pattern appears repeatedly in the artist's works. With the placement of a smaller black circle in the center of the composition, the image reads as a record album (or compact disc) with two gender ambiguous faces embroidered across the fabric. The figures are stripped down and drawn in a continuous white thread with only a minimal number of stitches used to secure them. In other areas, the thread is applied to the fabric in a gestural manner with loose strings and bits of almost imperceptible text and imagery appearing on the margins, striking an adroit balance between

technical skill and considered carelessness. A realistically rendered mushroom on the lower right corner appears to be an instance of self-quotation—mushrooms were among von Bonin's earliest stuffed motifs—and the adjacent outline of a hand drawn in blue thread reads as a sly gesture to the fact that these fabric works are made without evidence of the artist's own hand (the actual execution of the fabric pieces is outsourced, delegated to hired seamstresses).[8] The main motif—the androgynous faces—represents Daryl Hall and John Oates, American rockstars who rose to fame in the late 1970s and early 1980s, something one would not necessarily recognize without some prior knowledge.[9] Before we can consider why von Bonin would appropriate this anachronistic image of Hall and Oates, we are confronted with the stitched phrase "2 sissie boys from Heidelberg" running vertically down the left side of canvas, a text that comically conflates the conservative city of Heidelberg with gay culture, high camp, and American pop culture. The cryptic title phrase, "character appropriation," offers no further elucidation or synthesis, but rather underscores the artist's play with personas, positions, and identities, a game as cunning as it is evasive.

The specific materials chosen by von Bonin give added texture to this eclectic body of work, both literally and figuratively. Ranging from inexpensive, generic-looking patterns, to middle-class brands (Laura Ashley, Marks & Spencer), to high-end designers (Yves Saint Laurent, Prada, and Hermès), these readymade textiles come charged with references to contemporary lifestyle consumption and branding strategies that attempt to shape and embody the values and aspirations of a target group or culture. The artist's use of particular fabrics functions, on one level, as a wink of familiarity to the viewer / consumer in the know,

8 / Hands appear throughout von Bonin's fabric paintings, often taking the form of puffy, white cartoon hands expressing a variety of emphatic gestures similar to Mickey Mouse's magical conjuring hands in Walt Disney's *Fantasia* (1940). The proliferation of these disembodied hands underscores von Bonin's particular play with questions of authorial absence and presence and the valuation of artistic creation today.
9 / The probable source of this image is the band's 1975 self-titled album cover.

but it also creates moments of rupture as fashion and art combine—as one device among many through which modern subjects are conditioned and controlled. Likewise, von Bonin's stuffed animals also provocatively juxtapose the worlds of fine art, fashion, and luxury lifestyle branding.[10] Her recurring use of the French bulldog (the preferred pet of Yves Saint Laurent) has transformed this figure into a glorified logo, akin to the Izod crocodile or the Ralph Lauren polo player on horseback, but translated into a three-dimensional image and blown-up to absurd proportions. Situated on low pedestals fashioned to look like department store gift boxes, her stout dogs made of plush materials, from velour to tweed, are presented as upscale accessories or status objects.

When sited in and around her severe architectural sculptures, which recall shop displays and Minimalist design, as well as fences, gateways, and other everyday structures used to regulate movement or control behavior,[11] both her textile paintings and soft animals serve to dress up the artist's otherwise inhospitable environments. Unlike such hard, powder-coated structures as OFF MIRROR (BALCONY & TIRES) (2007), a wall-mounted balcony made with jail-like rails that contain two Formula One tires nestled up next to one another, or THRESHOLD (2006), a series of low, enameled steps that lead nowhere, the artist's animals and patchwork textiles offer welcome instances of color, warmth, intimacy, humor, and beauty. Through these affective juxtapositions, von Bonin creates a staged effect, one that invites the viewer to infer narrative settings or personal projections of empathy for her nonhuman protagonists. Community is suggested but withheld as these anthropomorphized characters are rarely allowed to congregate in groups. Their subjection to various forms of enclosure and, most recently, isolation in their own

10 / Von Bonin is certainly not alone in her critical exploration of the slippage between art, fashion, and high-end merchandise. In comparison to Japanese artist Takashi Murakami, an artist who has made branding one of his primary subjects, von Bonin's gesture is relatively subtle. While von Bonin tests and stretches the relationship between art object and consumable commodity, the distinction is never truly breached, whereas Murakami and others often strive to obliterate that difference. In 2008, for instance, Murakami placed a fully staffed Louis Vuitton store, selling pricey Murakami handbags designed in collaboration with Marc Jacobs, at the center of his retrospective at the Museum of Contemporary Art, Los Angeles.

11 / Bennett Simpson offers a valuable interpretation of these architectural structures in von Bonin's installations as literal and metaphorical instances of "control, domination, subordination, and friendship." See Simpson, "A Dog's Life," *Parkett*, no. 81 (2007): 57.

immersive soundscapes, makes it difficult for the viewer to decide whether to embrace them or just leave them alone.[12]

Isabelle Graw has compellingly interpreted the artist's notably increased deployment of anthropomorphized animals over the last decade as suggestive of a general tendency toward social segmentation or erosion, with these cartoonish animals assuming the role of human performers.[13] Graw posits von Bonin's profuse production of highly desirable, soft sculptures as an instance of strategic positioning on the part of the artist, a form of "feigned capitulation" to consumer drives and pressures in which von Bonin displays the market's codes, compulsions, and power relations, along with the associated costs for social relations: artistic alliances fall apart, art world centers shift, tastes change. Indeed, a paradoxical oscillation between confrontation and collusion with the market runs throughout her works. Von Bonin's conspicuous fabrication of these aesthetically appealing art objects perpetuates a cycle of production, consumption, and fatigue that critically mirrors not only the position of the artist but that of the oversaturated consumer / viewer overwhelmed and depressed by having to perform and commodify oneself all of the time. Her most recent series of slothflul rabbits, lethargic hermit crabs, and sluggish chicks—sprawled out on slick, modernist tables—emerge as loveable if ambiguous mascots for a weary society.

The increased prominence of Daffy Duck, a cartoon character who has loomed large in von Bonin's work over the past few years, shrewdly extends her engagement with anthropomorphized animals as both loose metaphors for a broken social network and stand-ins for the artist herself. As the foolish foil to the cunning Bugs Bunny, Daffy embodies a range of human vices, including pride, vanity, and envy.

12 / John Kelsey makes a similar observation concerning von Bonin's bulldogs in his article "The Mollusk of Reference," *Artforum* (November 2007): 339.

13 / See Isabelle Graw, "The Skipper's Loneliness: On Market Reflections, Social Contexts, Stuffed Animals, and Fashion Labels in the Work of Cosima von Bonin," *Cosima von Bonin: Roger and Out* (Los Angeles: Museum of Contemporary Art, 2007), 39 and 44.

His repeated tendency to invest great amounts of energy into schemes that end in failure, even self-destruction, comically illustrates the gulf that can exist between intention and achievement in the creative act. Daffy is always ready to take an energetic leap across the chasm, only to miss and fall into the abyss. Dirk von Lowtzow, a Berlin-based musician, art critic, and longtime collaborator of von Bonin's, has recently produced a series of scripted conversations between Daffy and von Bonin (the third installment of which appears in this exhibition catalog). With both sides penned by von Lowtzow, the dialogue is a work of fiction that upends the traditional notion of an artist interview.[14] Rather than a source of insight into von Bonin's motivations and working practice, the exchange between these two fictional characters is outlandish, dominated by Daffy's inflated self-image and propensity for irrational outbursts versus von Bonin's irritability and lethargy. Yet what at first appears to be a work of nonsense, a bit of comic relief, ends up articulating the artist's penchant for catalyzing rather than confirming associations in her work and for complicating notions of authorship and authenticity through reference and collaboration. With her incisive and provocative works, von Bonin stages a continuous push and pull between a charged demand for production, legitimacy, and social engagement, and an equally pressing desire to simply throw up our hands, duck behind a persona, and call for room service.

14 / The initial installment of Dirk von Lowtzow's serialized conversation, "Up a Chic Creek," was published in the catalog accompanying the first loop of von Bonin's series of *Lazy Susan* exhibitions at the Witte de With in 2010. The second, fourth, and fifth installments are planned to be published with subsequent loops of the series in Bristol, Geneva, and Cologne, respectively. Von Bonin has collaborated with von Lowtzow for almost a decade. His fanciful press releases for recent exhibitions of her work in Cologne and New York similarly redirected the traditional artist statement. He also collaborated on the 2004 video *2 Positionen auf einmal* (2 Positions at Once), as von Lowtzow's band Phantom / Ghost performed music written for the occasion. Von Bonin, in turn, created the cover imagery for three Phantom / Ghost releases: *Three* (2006), *Thrown Out of Drama School* (2009), and *For Shadows* (2010). For more on the 2004 video, see Bennett Simpson, "Heeling," in *Cosima von Bonin: Roger and Out*, 49–55.

Daffy Duck
and
Cosima von Bonin
in
Up a chic creek III

Dirk von Lowtzow

The Gobi desert, shortly before twilight. On the horizon, the outline of a black drake. Above his head, a black thundercloud from which lightning flashes at regular intervals and a warm drizzle falls, dampening his sable plumage.

DAFFY DUCK (*weeping from afar*): Woe is me! Banished! Sent out into the desert! Worst of all, to the depths of Absurdistan! 'Tis my downfall! How can I ever spread my wings here in exile? Farewell, vile world! Without thy joys, my life is but a bitter cup. And that this should happen to me—an actor who has known triumph on the world's stages, and above all at the Burgtheater. My kingdom for a chandelier! A full goblet of wine would mean more to me than all the gold on earth! Yes, even that old flounder Cosima von Bonin would be good company out here in this deserted desert! But I can only echo Lenin's words: what is to be done?

A second shadowy figure approaches from the opposite direction. It is Cosima von Bonin, pulling a fully laden mule behind her, a torrent of foul oaths and curses issuing from her lips.

COSIMA VON BONIN: Move, you obstinate onager! Call yourself a working animal…. How am I supposed to cross this stupid desert if I've got to drag you along after me? It's *you* that should be striding out ahead of *me*! A prince of asses! A personified avant-garde! But no—*dolce far niente*! Did anyone ever see the like?

(taking a gulp from one of the approximately 350 bottles of Coca-Cola she has brought with her)

Aaaah! Chill time! Glug-glug-glug! But when will this purgatory end? When can I find peace of mind and finally have my siesta? What trials are yet to come? And why here—why have I been sent out here? How many plagues must I yet endure? Seven? More?

(peering through a spy-glass and espying Daffy Duck, she recoils)

What the…? What scourge awaits me? Calamity looms! I'd rather face a tribe of Mongols, all armed to the teeth…. What is the black drake, this Satan incarnate, doing here? Is this some kind of test?

DAFFY DUCK *(approaching at a trot, declaiming)*: Zounds! What do my sore eyes behold? A mirage, a delusion, a walking shadow? A djinn, guardian of the desert? A barbarian? A highwayman? A bushranger, a brigand? Does he bear a shield and coat-of-arms, perhaps even a sabre? Zounds! A brace of the villains! He has a mule with him!

(to himself)

Fortune favors the brave! Daffy, be strong! Be valiant!

(addressing Cosima von Bonin with exaggerated courtesy)

O gentleman of the highroad, what fair wind blows thee hither?

(recognizing Cosima von Bonin)

It is she! How can this be…? Madame…, how de-light-ful. How de-light-ful to see you here. Tears are springing to my eyes and coursing down my wordly-wise cheeks like mountain rivulets. Tears of joy—for what could be finer than to meet a compatriot in foreign parts?

COSIMA VON BONIN *(to herself)*: It's beyond belief! The horror of it all! The ham pursues me to the very ends of the earth.

(to Daffy)

Spare me your drivel! This drag–ass here is quite bad enough—the beast's so obstinate there ought to be a law against it! What the *hell* are you doing here?

DAFFY DUCK: Please forgive my presence. I have long been aware how unworthy a creature I am in Your Excellency's eyes—tinier than a grain of dust on the planet Uranus, where the gases are so heavy that reptiles have to crawl. I am only too aware of my unpopularity—only too aware of my loneliness.... All I have left are the baby tits! I am a blackguard, oh yes, a blackguard. But, Madame, I pine for you. I long to be at least your erstwhile friend. I long to be backstage! Backstage! That's all I wish for!

(tears springing to his eyes)

But....

(sobbing)

Just as I think yes, now I'm backstage, yes, Daffy, now you've made it, you've got there, *finalement*, another door opens, with "Backstage" and "Artists only" (whatever that's supposed to mean) in huge letters, and outside it there's a Securitate man demanding my bracelet or ID or whatever stupid thing you're expected to have, and I think to myself I must have collected about 2000 of those damn bracelets and cards and IDs, and what good are all these knickknacks to me now?

(talking himself into a rage, his rear end bobbing, his face red with fury, his wings waving around)

And inside the door there's another door, and inside that yet another door with yet another guard, and I don't know the *damn* password I need to get into this accursed lodge. This house isn't a home, let me tell you, and if you haven't got a home nowadays.... It's a picture puzzle, every surface crooked, trapdoors at every turn, next thing you know the doorknob's come off in your hand and you can't get back. Once you're backstage, you've had it. Once you're deep in the brambles, there's no way out.

(weeping)
Waaaaahhhh! It's all too much! I'm just a baby! I want things the way
they used to be!

(recovering his composure, and wiping the dust from his feathers)
Madame, forgive me, I am a monster, but... I just long to be
backstage! To be at your side! To be your erstwhile friend. Grant me
this one boon!

(flinging himself to the ground with theatrical abandon)
Rome is burning! 'Tis my downfall! Valium! Quickly! Valium! I perish!
Alack!

COSIMA VON BONIN: For God's sake, Daffy, get a grip on yourself! How
can anyone be expected to watch such a regressive display—in the
Gobi desert, of all places? And who's it all for? Not for me, anyway.
This ass has been quite enough of a pain already. And there isn't
another soul around here. Beneath the sand—now that's where you
might find an audience. Worms. Woodlice, a brood of vipers and,
I gather, a few fossils too. But first let me order you a cucumber
sandwich. It'll do you good.

*(fumbling in the pockets of her desert attire, she produces a phone
and types a number)*
Hallo? Porter? Bonin speaking! I'd like to order a cucumber
sandwich—yes, that's right..., er..., yes. And for me a club sandwich,
yes, that's right, with fries, of course. No, I've got my own supply
of Coca-Cola. Well, thank you—that'll be all then. Oh, and a ton of
valium, please. Thank you so much.

(putting the phone back in her pocket)
Well, you can say what you like about this desert, but the service is
excellent.

À suivre

Translated by Kevin Cook, Nijmegen, Netherlands.

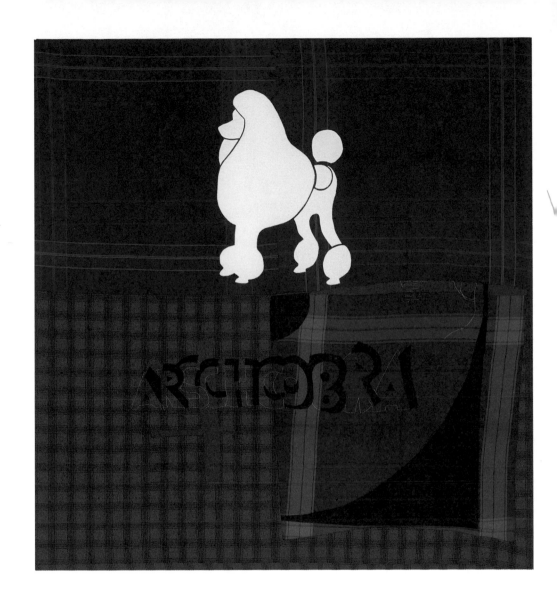

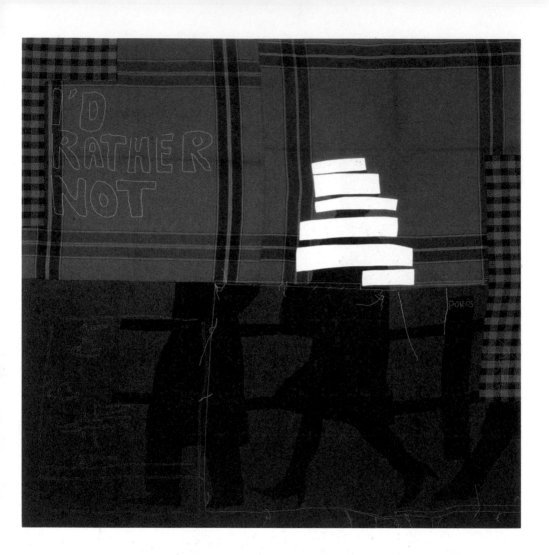

GROßE KÜCHE (CRUDE CUISINE), 2003

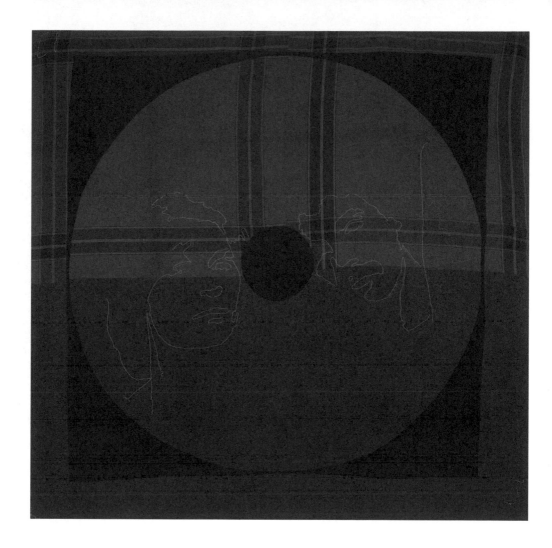

ROCKSTARS (CHARACTER APPROPRIATION) (ROLLENANEIGNUNG), 2003

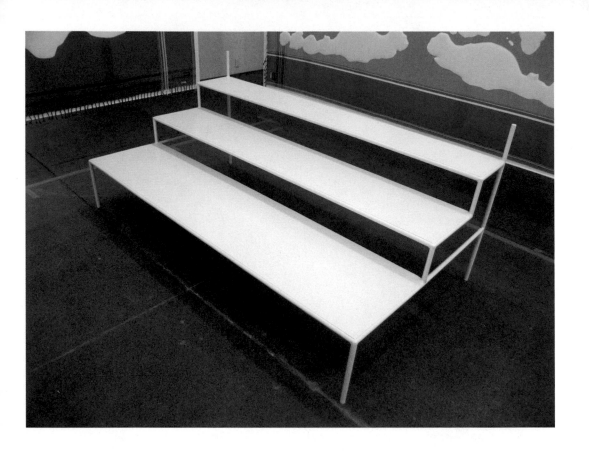

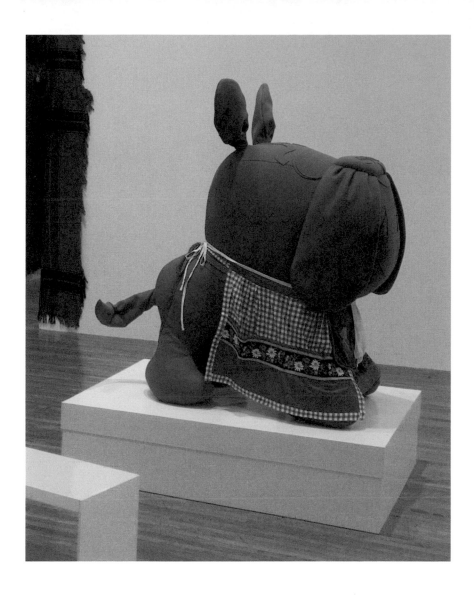

UNTITLED (THE GREY BULLDOG WITH BOX & APRONS), 2006

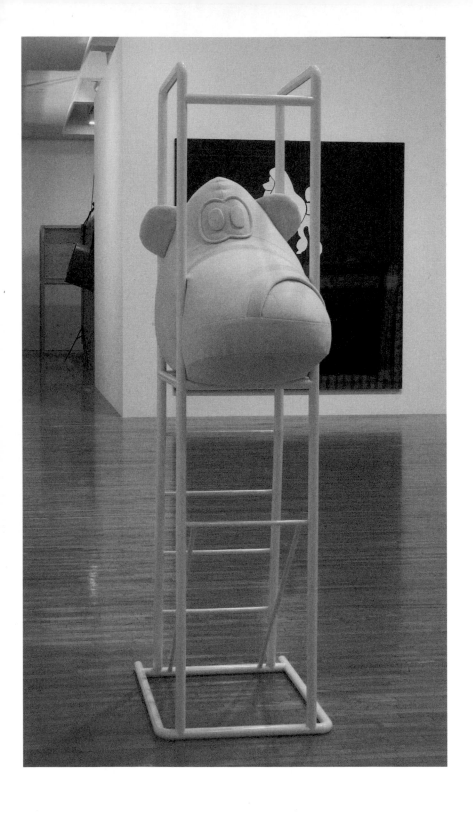

SCHUH / SHOE, 2007

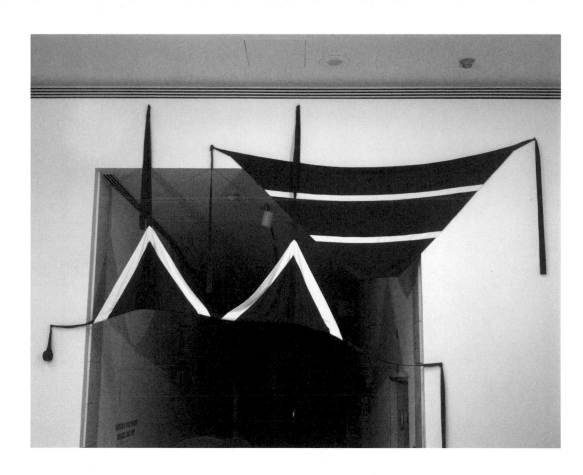

UNTITLED (BIKINI LOOP #01), 2007

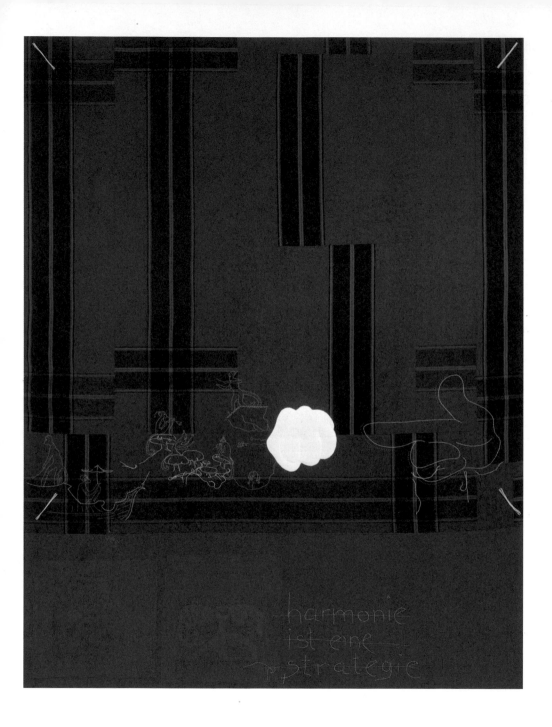

harmonie
ist eine
strategie

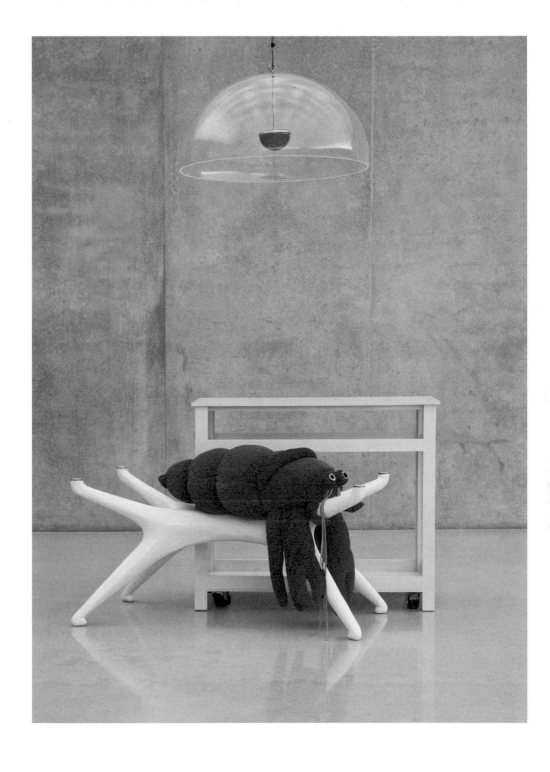

THE BONIN / OSWALD EMPIRE'S NOTHING #05 (CVB'S SANS CLOTHING. MOST RISQUÉ. I'D BE DELIGHTED. & MVO'S ORANGE HERMITCRAB ON OFF-WHITE TABLE NEXT TO PINK TABLE SONG), 2010

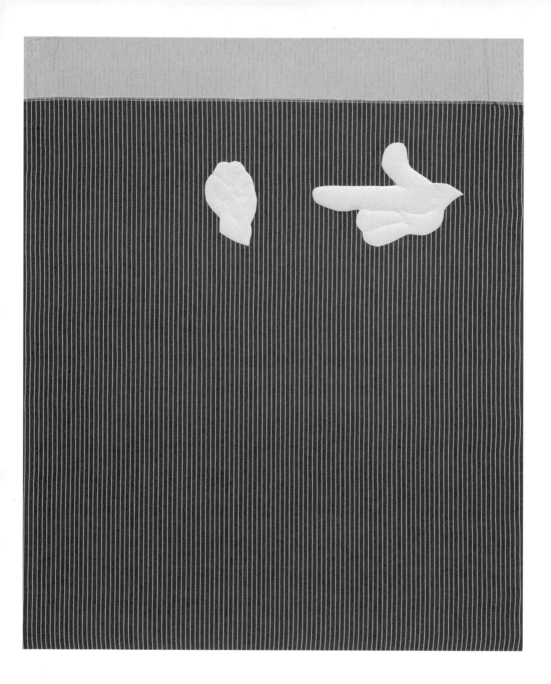

BUBBLES (LOOP #03), 2010

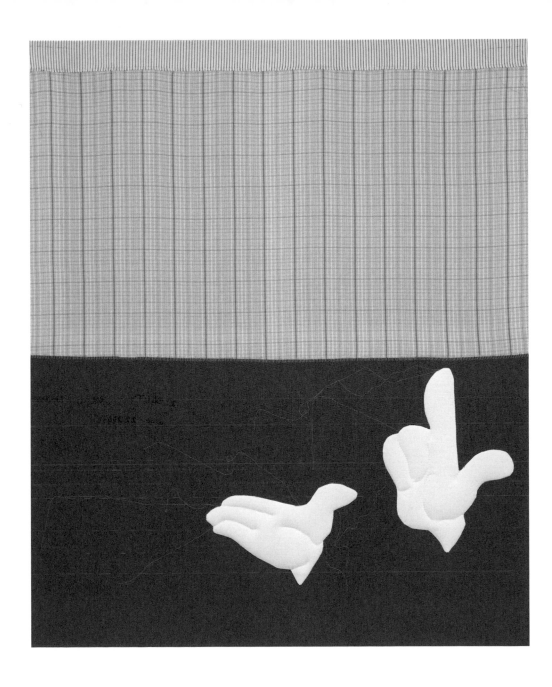

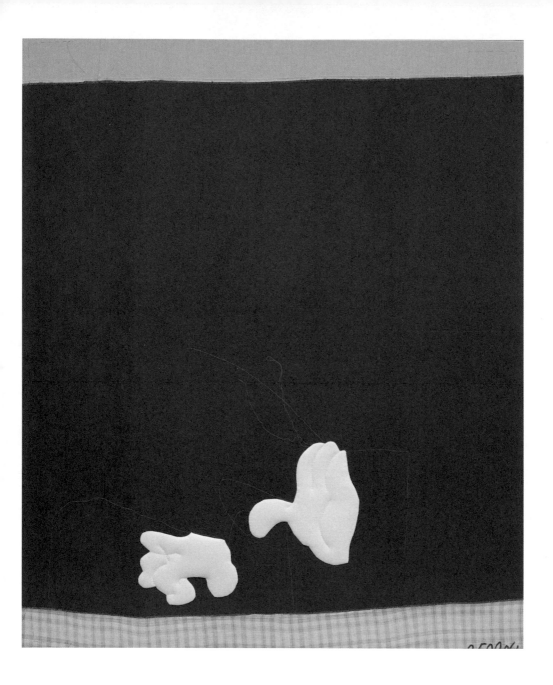

BUBBLES (LOOP #11), 2010

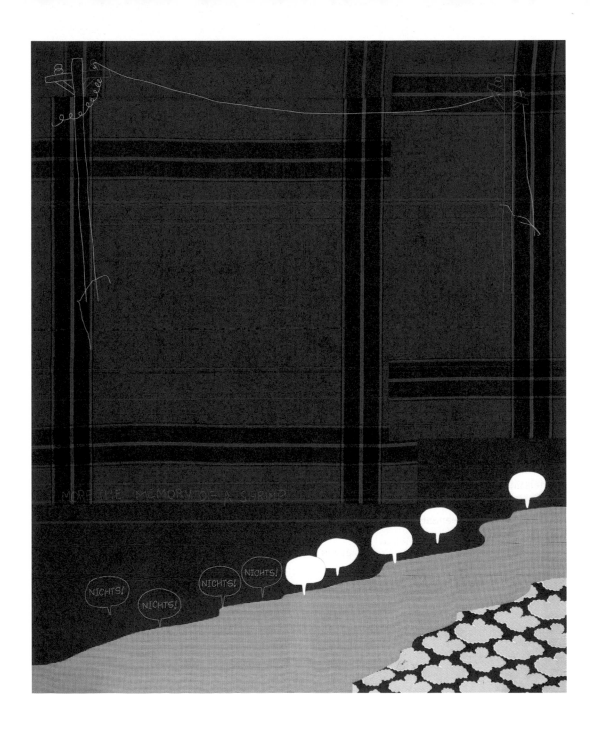

NOTHING #07 (MORE THE MEMORY OF THE SHRIMP), 2010

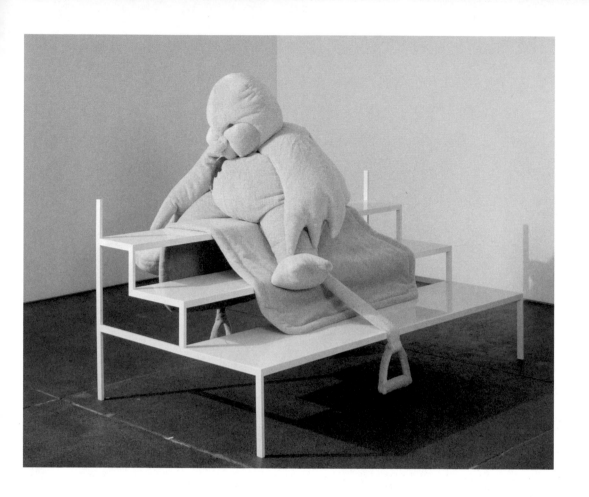

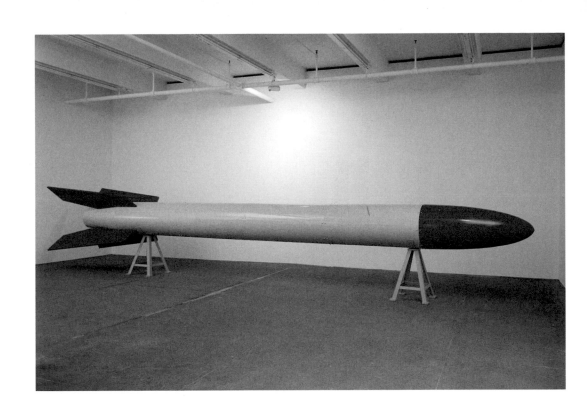

MISSY MISDEMEANOUR #02 (THE BEIGE VOMITING CHICK, MISS RILEY [LOOP #02, 2006], MVO'S VOODOO BEAT & MVO'S ROCKET BLAST BEAT), 2011

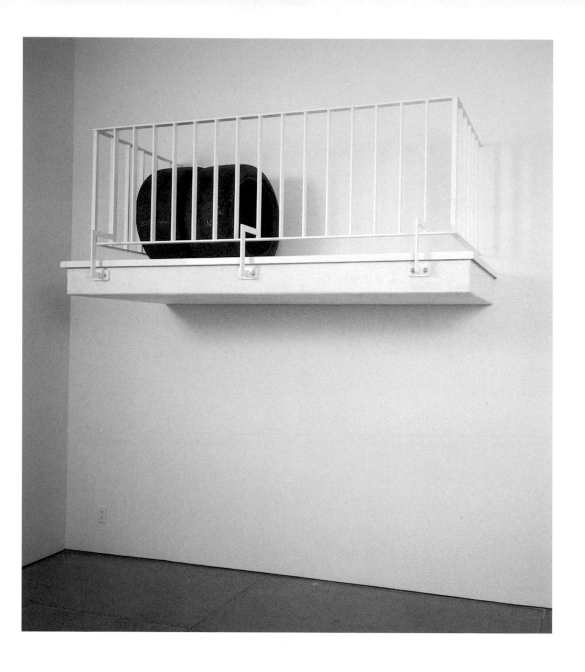

OFF MIRROR / THE ST. LOUIS VERSION (BALCONY & TIRES, 2007, &
MVO'S ST. LOUIS BEAT), 2011

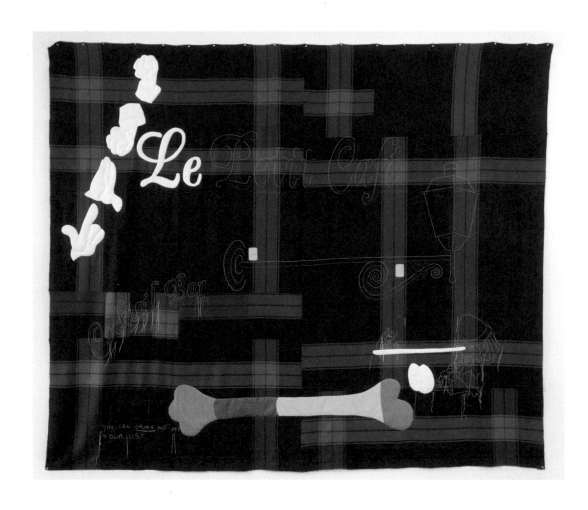

LE PETIT CAFÉ / THE NEW YORK FABRIC VERSION (WITH MVO'S
LE PETIT CAFÉ BEAT), 2011

CHECKLIST OF THE EXHIBITION*

ARSCH COBRA, 2003
WOOL AND COTTON, 117^5/$_{16}$ X 110^1/$_4$"
COLLECTION OF CRAIG ROBINS, MIAMI,
FLORIDA
ILL. P. 27

GROBE KÜCHE (CRUDE CUISINE), 2003
WOOL, COTTON, AND LODEN,
108^3/$_4$ X 110^1/$_4$"
CARLOS AND ROSA DE LA CRUZ
COLLECTION
ILL. P. 28

ROCKSTARS (CHARACTER APPROPRIATION) (ROLLENANEIGNUNG), 2003
WOOL, COTTON, AND LODEN,
108^7/$_8$ X 110^3/$_8$"
MILDRED LANE KEMPER ART MUSEUM,
WASHINGTON UNIVERSITY IN ST. LOUIS
UNIVERSITY PURCHASE, PARSONS FUND,
AND WITH FUNDS FROM MRS. MARK C.
STEINBERG, BY EXCHANGE, 2003
ILL. P. 29

THRESHOLD, 2006
WOOD, STEEL, AND LACQUER,
78^3/$_4$ X 47^1/$_4$ X 39^3/$_8$"
COURTESY OF THE ARTIST AND
FRIEDRICH PETZEL GALLERY, NEW YORK
ILL. P. 30

UNTITLED (THE GREY BULLDOG WITH BOX & APRONS), 2006
VARIOUS MATERIALS,
50 X 36^1/$_{16}$ X 47^7/$_8$"
CARLOS AND ROSA DE LA CRUZ
COLLECTION
PHOTO: BRIAN FORREST
ILL. P. 31

SCHUH / SHOE, 2007
WOOL, FLEECE, AND POWDER-COATED
STEEL, 27^{15}/$_{16}$ X 37^3/$_8$ X 18^1/$_2$"
(SHOE) AND 87^1/$_2$ X 23^3/$_4$ X 25"
(BASE)
COURTESY OF THE ARTIST AND
FRIEDRICH PETZEL GALLERY, NEW YORK
PHOTO: BRIAN FORREST
ILL. P. 32

UNTITLED (BIKINI LOOP #01), 2007
FLAG FABRIC, DIMENSIONS VARIABLE
MUSEUM OF CONTEMPORARY ART, LOS
ANGELES
PURCHASED WITH FUNDS PROVIDED BY
THE ACQUISITION AND COLLECTION
COMMITTEE
PHOTO: BRIAN FORREST
ILL. P. 33

HAND VON RECHTS, 2008
WOOL, COTTON, AND FLEECE,
86^5/$_8$ X 66^{15}/$_{16}$"
COURTESY OF THE ARTIST AND
FRIEDRICH PETZEL GALLERY, NEW YORK
ILL. P. 34

* Unless otherwise noted all photographs are by Lamay Photo

THE BONIN / OSWALD EMPIRE'S NOTHING #05 (CVB'S SANS CLOTHING. MOST RISQUÉ. I'D BE DELIGHTED. & MVO'S ORANGE HERMITCRAB ON OFF-WHITE TABLE NEXT TO PINK TABLE SONG), 2010

VARIOUS MATERIALS, $29^1/_8$ X $29^1/_8$
X $58^{11}/_{16}$" (WHITE TABLE), $43^{15}/_{16}$
X $25^1/_4$ X $51^1/_4$" (PINK TABLE),
AND $19^3/_4$ X $23^5/_8$ X $39^7/_{16}$" APPROX
(CRAB)
COURTESY OF THE ARTIST AND GALERIE
DANIEL BUCHHOLZ, COLOGNE
PHOTO: MARKUS TRETTER
ILL. P. 35

BUBBLES (LOOP #03), 2010

COTTON, $66^{15}/_{16}$ X $55^1/_8$"
COURTESY OF THE ARTIST AND
FRIEDRICH PETZEL GALLERY, NEW YORK
ILL. P. 36

BUBBLES (LOOP #10), 2010

COTTON, $66^{15}/_{16}$ X $55^1/_{16}$"
COURTESY OF THE ARTIST AND
FRIEDRICH PETZEL GALLERY, NEW YORK
ILL. P. 37

BUBBLES (LOOP #11), 2010

COTTON, $66^{15}/_{16}$ X $55^1/_{16}$"
COURTESY OF THE ARTIST AND
FRIEDRICH PETZEL GALLERY, NEW YORK
ILL. P. 38

NOTHING #07 (MORE THE MEMORY OF THE SHRIMP), 2010

WOOL, COTTON, AND LODEN,
$90^1/_{16}$ X $79^1/_8$"
COURTESY OF THE ARTIST AND
FRIEDRICH PETZEL GALLERY, NEW YORK
ILL. P. 39

MISSY MISDEMEANOUR #02 (THE BEIGE VOMITING CHICK, MISS RILEY [LOOP #02, 2006], MVO'S VOODOO BEAT & MVO'S ROCKET BLAST BEAT), 2011

VARIOUS MATERIALS, 60 X 48 X 60"
APPROX (CHICK) AND $433^1/_{16}$ X 20" DIA
(ROCKET)
COURTESY OF THE ARTIST AND
FRIEDRICH PETZEL GALLERY, NEW YORK
ILL. PP. 40, 41

OFF MIRROR / THE ST. LOUIS VERSION (BALCONY & TIRES, 2007, & MVO'S ST. LOUIS BEAT), 2011

POWDER-COATED STEEL RAILING,
FIBERBOARD, CONCRETE PLASTER,
AND FORMULA ONE TIRES,
$37^3/_8$ X $92^1/_8$ X $35^7/_{16}$"
COURTESY OF THE ARTIST AND
FRIEDRICH PETZEL GALLERY, NEW YORK
ILL. P. 42

LE PETIT CAFÉ / THE NEW YORK FABRIC VERSION (WITH MVO'S LE PETIT CAFÉ BEAT), 2011

WOOL AND COTTON, $99^3/_{16}$ X $116^{15}/_{16}$"
COLLECTION DE BRUIN-HEIJN
ILL. P. 43

SUPPLEMENTAL IMAGE

THE BONIN / OSWALD EMPIRE'S NOTHING #01 (CVB'S VOMITING CHICK & MVO'S VOMIT!), 2010 (DETAIL)

MOHAIR, POLYFILL, ARNE JACOBSEN
FORM, AND STOOL, DIMENSIONS
VARIABLE
PHOTO: MARKUS TRETTER
ILL. P. 5

BIOGRAPHY

Born in 1962 in Mombasa, Kenya, **Cosima von Bonin** lives and works in Cologne, Germany. In 2010, the Kunsthaus Bregenz presented *The Fatigue Empire*, a comprehensive one-person exhibition of the artist's recent works. An international traveling exhibition, *Lazy Susan Series, A Rotating Exhibition*, followed with venues at the Witte de With, Rotterdam (10.2010); Arnolfini, Bristol (2.2011); MAMCO, Geneva (6.2011); and Museum Ludwig, Cologne (7.2011). Von Bonin's first major survey exhibition in the United States, *Roger and Out*, took place at the Museum of Contemporary Art, Los Angeles (2007). Other recent solo exhibitions include Kölnischer Kunstverein, Cologne (2004); Kunstverein Hamburg (2001); and Kunstverein Braunschweig (2000). Von Bonin has participated in numerous group exhibitions, including *Collecting History: Highlighting Recent Acquisitions* (Museum of Contemporary Art, Los Angeles, 2009); *Compass in Hand: Selections from The Judith Rothschild Foundation Contemporary Drawings Collection* (Museum of Modern Art, New York, 2009); *Entr'acte* (CCS Bard, Annandale-on-Hudson, 2009); *Le Printemps de Septembre–à Toulouse* (Les Abbatoirs, Toulouse, 2009); *Eyes Wide Open* (Stedelijk Museum, Amsterdam, 2008); *Documenta XII* (Kassel, 2007); and *Make Your Own Life: Artists In and Out of Cologne* (Institute of Contemporary Art, University of Pennsylvania, Philadelphia, 2006). Von Bonin's work is included in many important public collections, such as Tate Britain, London; Museum für Neue Kunst im ZKM, Karlsruhe; Stedelijk Museum, Amsterdam; Museum of Contemporary Art, Los Angeles; Museum of Modern Art, New York; and the Mildred Lane Kemper Art Museum, St. Louis.

CONTRIBUTORS

Meredith Malone is associate curator at the Mildred Lane Kemper Art Museum at Washington University in St. Louis.

Dirk von Lowtzow is a Berlin-based musician. He writes the songs, sings, and plays guitar with the German rock group Tocotronic, with whom he has produced nine albums since 1995. In 2000, he cofounded the musical project Phantom Ghost together with Thies Mynther. He also works as an art critic and has published in *Texte zur Kunst* as well as in several catalogs. He has worked as a slave for Cosima von Bonin for almost ten years.

Moritz von Oswald works in the fields of electronic beats and club music. An abridged selection of his projects includes collaborations with Detroit techno producers Blake Baxter, Juan Atkins and Underground Resistance, and ventures such as Basic Channel, Main Street, Round One to Round Five, Maurizio and Rhythm & Sound with Mark Ernestus. Currently his focus is on enterprises such as the Moritz von Oswald Trio, collaborations with Francesco Tristano, or DJ sets with Tikiman (Paul St. Hilaire), among others. He lives and works in Berlin. Moritz von Oswald and Cosima von Bonin met in 2009 and have worked together since 2010.

ACKNOWLEDGMENTS

The Mildred Lane Kemper Art Museum would like to thank the lenders to the exhibition for generously making work from their collections available for this installation. Special thanks also go to Dirk von Lowtzow for his humorous contribution to the publication, and to Moritz von Oswald for his soundtracks and his performance in St. Louis. Translator Kevin Cook expertly adapted von Lowtzow's text from German into English. Several members at the Friedrich Petzel Gallery provided essential support, including Friedrich Petzel, Andrea Teschke, and Seth Kelly. The staff at the Kemper Art Museum was instrumental in making this project a success. Thanks go especially to Kim Broker, Eileen G'Sell, Jan Hessel, Rachel Keith, Jane Neidhardt, and Ron Weaver. Finally, personal thanks to Cosima von Bonin for her extraordinary work and creative collaboration.

RELATED EVENTS

Friday, May 6, 2011
Opening
6–7 pm, Member Preview
7–9 pm, Public Opening
10 pm, Afterparty with DJ set by Moritz von Oswald at Atomic Cowboy (4140 Manchester Rd., St. Louis)

Saturday, May 7, 2011
1 pm, Gallery Walkthrough with Meredith Malone, exhibition curator

Friday, June 17, 2011
Gallery Talk and Outdoor Film: *Dr. Strangelove or: How I Learned to Stop Worrying and Love the Bomb*
7 pm, Gallery Talk
8:30 pm, Film Screening

This catalog was produced in conjunction with the exhibition *Cosima Von Bonin: Character Appropriation*, curated by Meredith Malone at the Mildred Lane Kemper Art Museum, on view May 6 to August 1, 2011.

Support for the exhibition and publication was provided by James M. Kemper, Jr.; the David Woods Kemper Memorial Foundation; John and Anabeth Weil; the Hortense Lewin Art Fund; and members of the Mildred Lane Kemper Art Museum.

Published by
Mildred Lane Kemper Art Museum
Sam Fox School of Design & Visual Arts
One Brookings Drive, Campus Box 1214
Washington University
St. Louis, Missouri 63130
kemperartmuseum.wustl.edu

Editor: Jane E. Neidhardt, St. Louis
Editorial assistant: Eileen G'Sell, St. Louis
Translator: Kevin Cook, Nijmegen,
 Netherlands
Designer: Michael Worthington,
 Counterspace, Los Angeles
Printer: Shapco Printing, Inc.,
 Minneapolis

Library of Congress Control Number: 2011927791
ISBN: 978-0-936316-33-8

Front cover:
HAND VON RECHTS, 2008 (detail)
Inside front and back covers:
ROCKSTARS (CHARACTER APPROPRIATION) (ROLLENANEIGNUNG), 2003 (details)

Washington University in St. Louis
SAM FOX SCHOOL OF DESIGN & VISUAL ARTS